DRAW **50**
PEOPLE

BOOKS IN THIS SERIES

Draw 50 Airplanes, Aircraft, and Spacecraft
Draw 50 Animals
Draw 50 Athletes
Draw 50 Beasties and Yugglies and Turnover Uglies and Things That Go
Bump in the Night
Draw 50 Boats, Ships, Trucks, and Trains
Draw 50 Buildings and Other Structures
Draw 50 Cars, Trucks, and Motorcycles
Draw 50 Cats
Draw 50 Creepy Crawlies
Draw 50 Dinosaurs and Other Prehistoric Animals
Draw 50 Dogs
Draw 50 Endangered Animals
Draw 50 Famous Caricatures
Draw 50 Famous Cartoons
Draw 50 Famous Faces
Draw 50 Holiday Decorations
Draw 50 Horses
Draw 50 Monsters, Creeps, Superheroes, Demons, Dragons, Nerds, Dirts,
Ghouls, Giants, Vampires, Zombies, and Other Curiosa . . .
Draw 50 Sharks, Whales, and Other Sea Creatures
Draw 50 Vehicles
Draw 50 People

DRAW 50 PEOPLE

Lee J. Ames
with Creig Flessel

MAIN STREET BOOKS

DOUBLEDAY

NEW YORK LONDON TORONTO SYDNEY AUCKLAND

PUBLISHED BY DOUBLEDAY
a division of Bantam Doubleday Dell Publishing Group, Inc.
1540 Broadway, New York, New York 10036

DOUBLEDAY
and the portrayal of an anchor with a dolphin
are trademarks of Doubleday,
a division of Bantam Doubleday Dell Publishing Group, Inc.,

Library of Congress Cataloging-in-Publication Data

Ames, Lee J.
 Draw 50 people / Lee J. Ames with Creig Flessel.—1st ed.
 p. cm.
 1. Portrait drawing—Technique. I. Flessel, Creig. II. Title.
III. Title: Draw fifty people.
NC773.A46 1993 93-20631
743'.4—dc20 CIP

ISBN: 0-385-41193-6

We, Creig and Lee,
raise a toast,
a Berndt Toast,
to a prince among people,
Chuck Harriton,
who will be sorely missed.

Author's Note

I have known, respected, and admired Creig for over thirty years. In our Berndt Toast Gang, the largest branch of the National Cartoonist's Society, Creig, our leader, whom we have dubbed "The Infallible," and whose light, bright, and lusty drawings have enchanted us for decades, offers these thoughts . . .

Writers, critics, and artists have for aeons tried to describe and explain drawing. They have written: "He's a great draughtsman"; "He draws with calligraphic verve"; ". . . a linear delight with a personal, exciting line." Etcetera, etcetera.

What do they mean?

Picasso, Ingres, and Mary Cassatt were great draughtspersons, but were all very different. John Singer Sargent's delightful calligraphic brush strokes were exciting. Picasso's line was honest. The art of drawing has been analyzed, dissected, and even "Freudianized" through the ages by expert and dilettante critics. So let's get personal and get to the basics: What is a drawing?

Our tools can be pencil, pen, charcoal, pastel, a computer, and, of course, the right side of the brain.

In art school in 1932, my instructor was the legendary Harvey Dunn, a mountain of a man who used a two-inch-wide brush. He used his drawing skill by daubing the paint on his canvas in a thick impasto. He blended his shapes and colors by twirling his brush in the heavy paint. We stood in awe and murmured, "Some draughtsman! Wow!"

Mario Cooper, our class monitor, used colored inks, photographs, and watercolors to produce his fine slick illustrations. He later earned an outstanding reputation as one of our top magazine artists. "Great draughtsman," we murmured.

I soon found myself delighted with the work of giants like Noel Sickles, Al Dorne, Austin Briggs, Dik Browne, Stan Drake, Lou Fine, and Alex Kotsky. All great draughtsmen. The best!

Dik Browne's palette, when he was working on his comic strip "Hagar the Horrible," looked like Jackson Pollock's paint rags. His brushes were frayed.

His pens were thickly caked with India ink. But what a great draughtsman, he was!

In contrast, Alex Kotsky is meticulously neat when he works on his comic strip, "Apartment 3G." Stan Drake, who formerly drew "The Heart of Juliet Jones" and is now doing "Blondie," used photographs projected onto the surface of his drawing paper. Super draughtsmen? Definitely.

It has taken me a lifetime to answer this question: What is a drawing? Better still, what is *my* drawing? Of course, I can't be objective or offer a quick, simple answer. I know what emerges is a part of me. It is my own mark, my stamp.

I've been told, "Your drawings are better than your finished paintings." How true. I try to keep the original thought and the creative excitement all the way through to my finished artwork. But sometimes the clear, spontaneous concept becomes muddled and overworked. The real draughtsmanship is accomplished with the first marks of a pencil, pen, or brush.

Many of us make renderings, renderings that are detailed delineations, shaped, shaded, and detailed to a fare-thee-well. I have rendered many turkeys! But once in a while, I make a drawing!

This is indeed another "Draw 50," with emphasis on basic construction of the human figure. It is my wish that it may free you to be you and to draw, not render.

CREIG FLESSEL

To the Reader

When you start working I suggest you use clean white bond paper or drawing paper and a pencil with moderately soft lead (HB or No. 2). Keep a kneaded eraser (available at art supply stores) handy. Choose the subject you want to draw and then, very lightly and very carefully, sketch out the first step. Also very lightly and carefully, add the second step. As you go along, study not only the lines but the spaces between the lines. Size your first steps to fill your drawing paper agreeably, not too large, not too small. Remember, the first steps must be constructed with the greatest care. A mistake here could ruin the whole thing.

As you work, it's a good idea, from time to time, to hold a mirror to your sketch. The image in the mirror frequently shows distortion you might not have recognized otherwise.

You will notice new step additions are printed darker. This is so they can be clearly seen. But keep your construction steps always very light. Here's where the kneaded eraser can be useful. You can lighten a pencil stroke that is too dark by pressing on it with the eraser.

When you've completed all the light steps and are sure you have everything the way you want it, finish your drawing with firm, strong penciling. If you like, you can go over this with India ink (applied with a fine brush or pen), or a permanent fine-tipped ballpoint or felt-tipped marker. When your work is thoroughly dry, you can then use the kneaded eraser to clean out all the underlying pencil marks.

Remember, if your first attempts at drawing do not turn out the way you'd like, it's important to *keep trying*. Your efforts *will* eventually pay off, and you'll be pleased and surprised at what you can accomplish. I sincerely hope, as you follow our techniques, you'll improve your own skills. Mimicking the drawings in this book can open the door to your own creativity. Now have a great time drawing us, drawing people!

LEE J. AMES

DRAW 50
PEOPLE

Neanderthal Woman and Man

Cleopatra and the Asp (Egyptian Cobra)

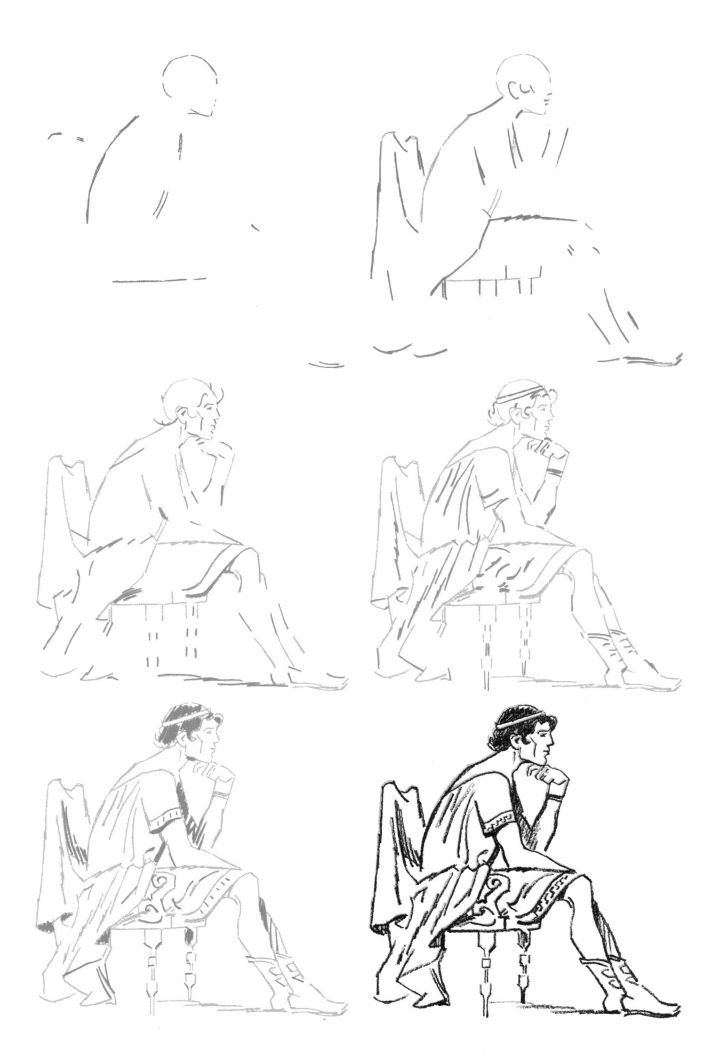

Young Alexander the Great

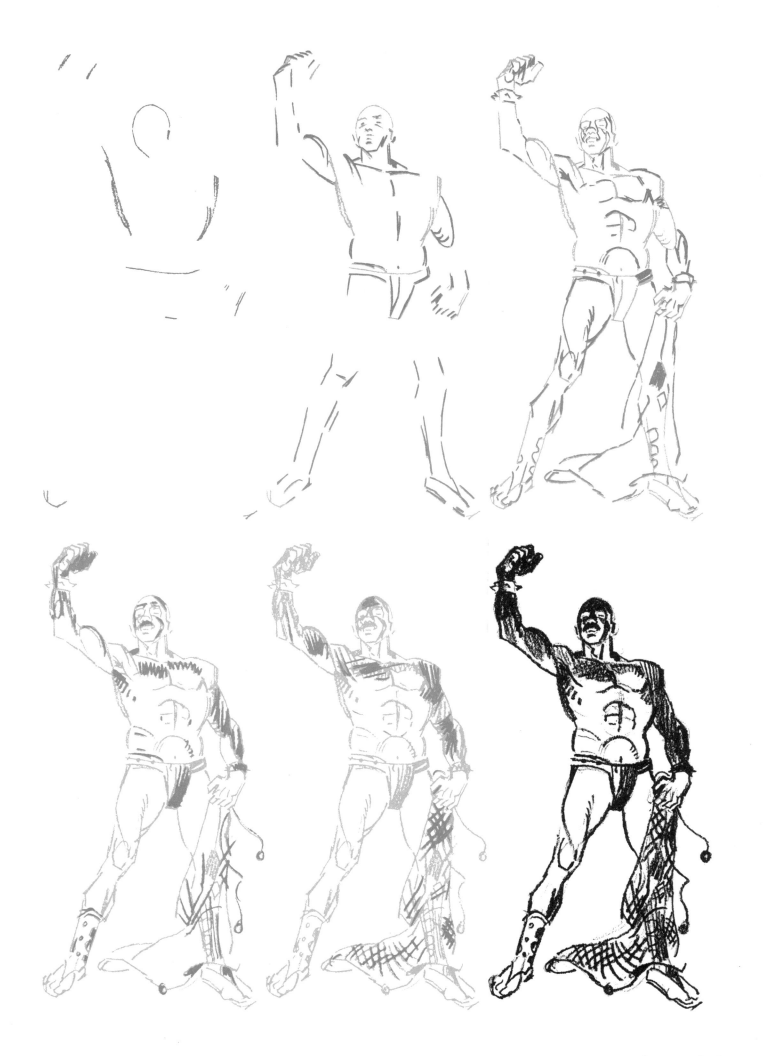

African Gladiator

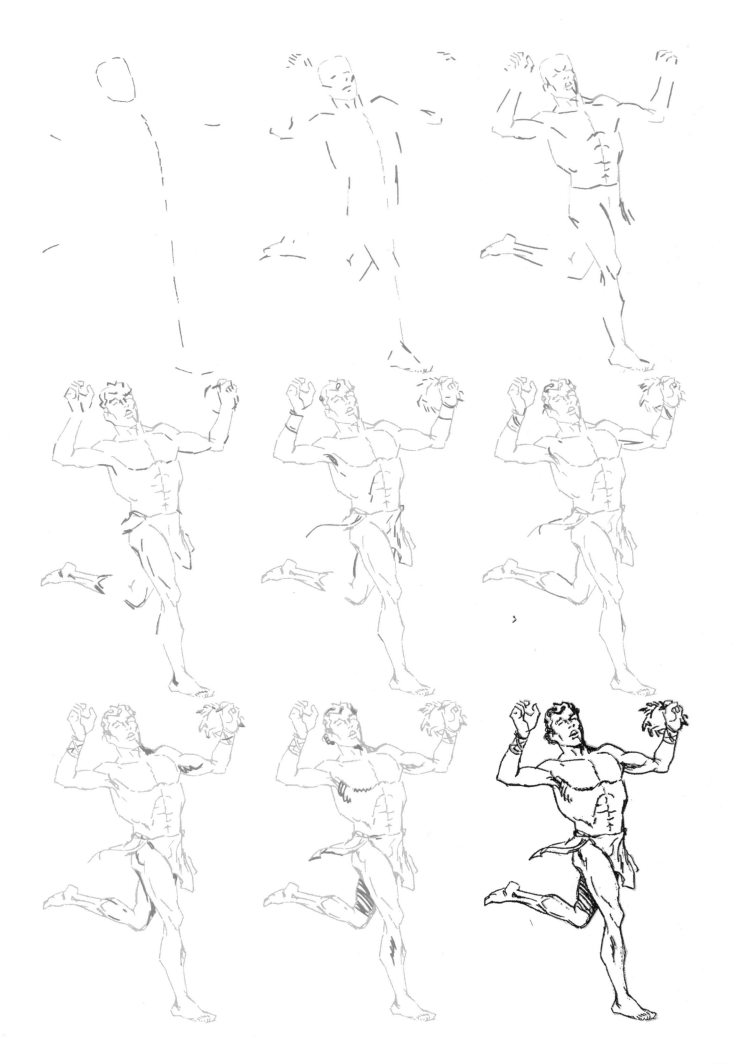

Victorious Roman Athlete

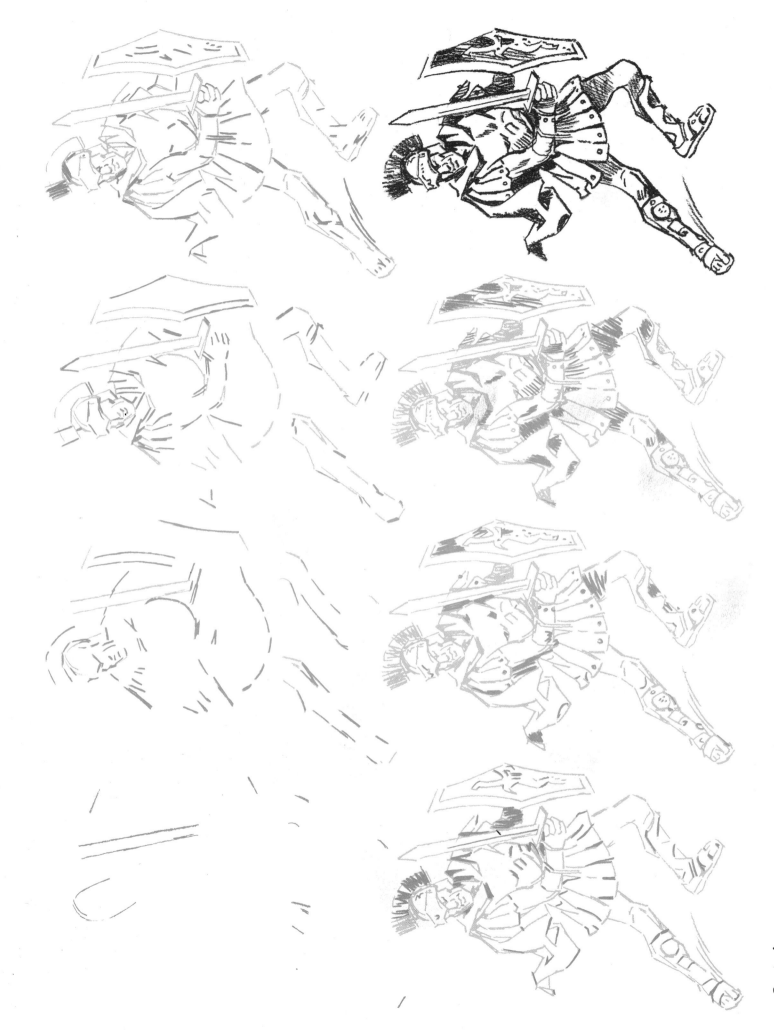

Roman Centurion

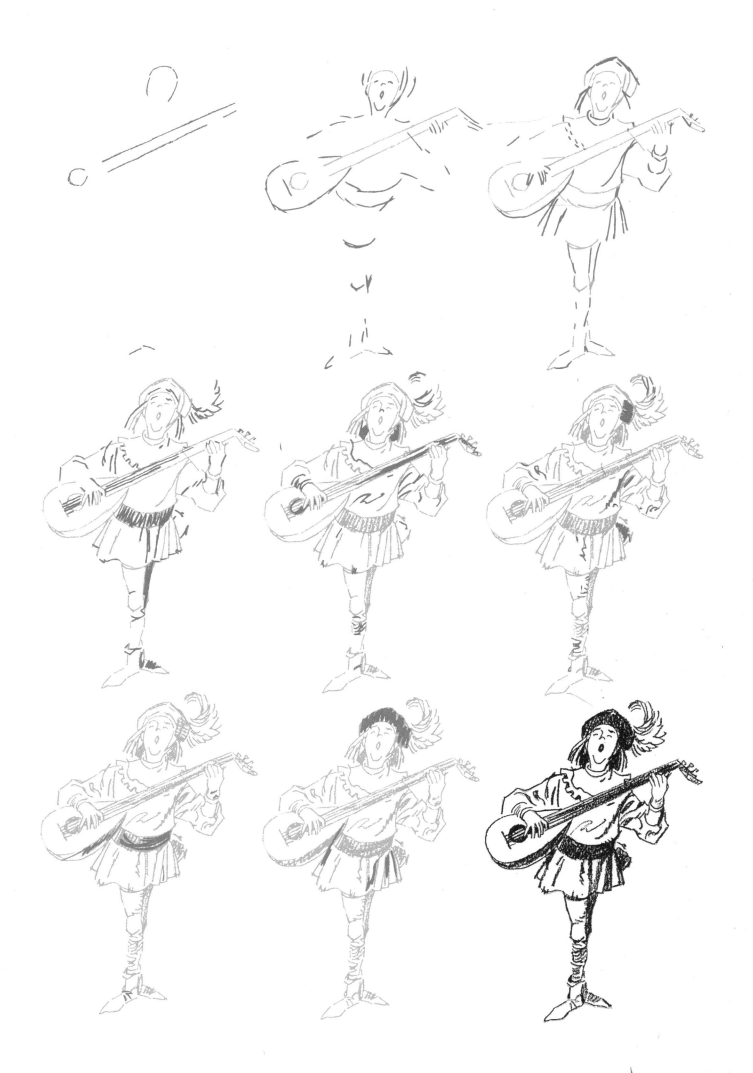

Medieval Troubadour

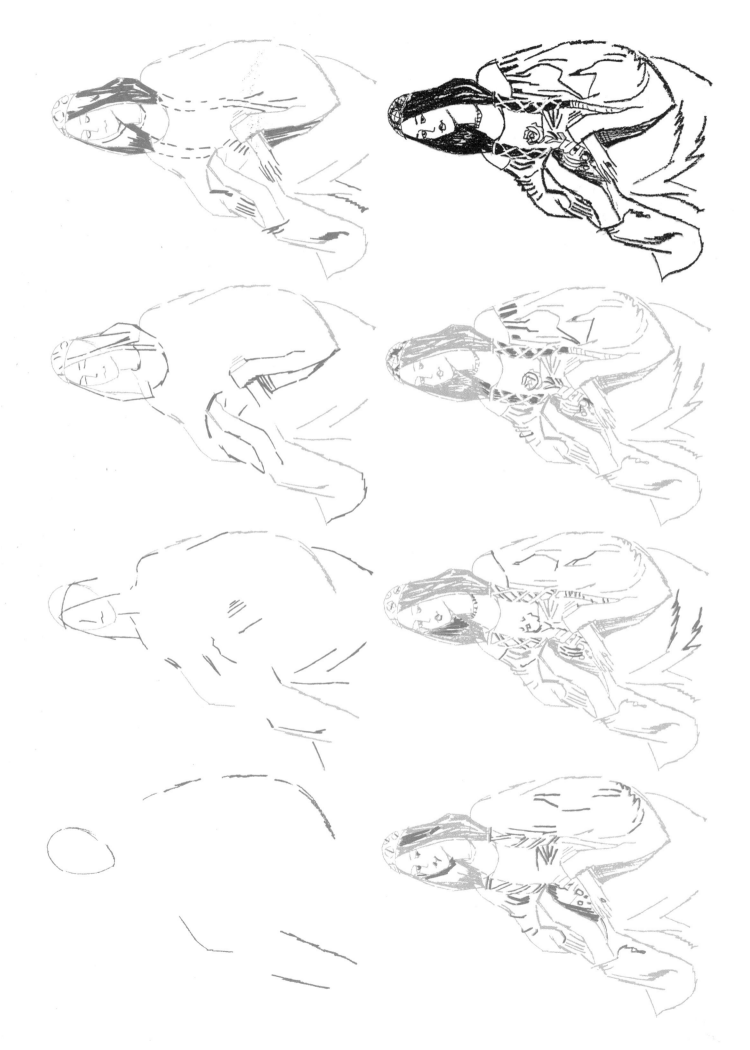

Queen Guinevere

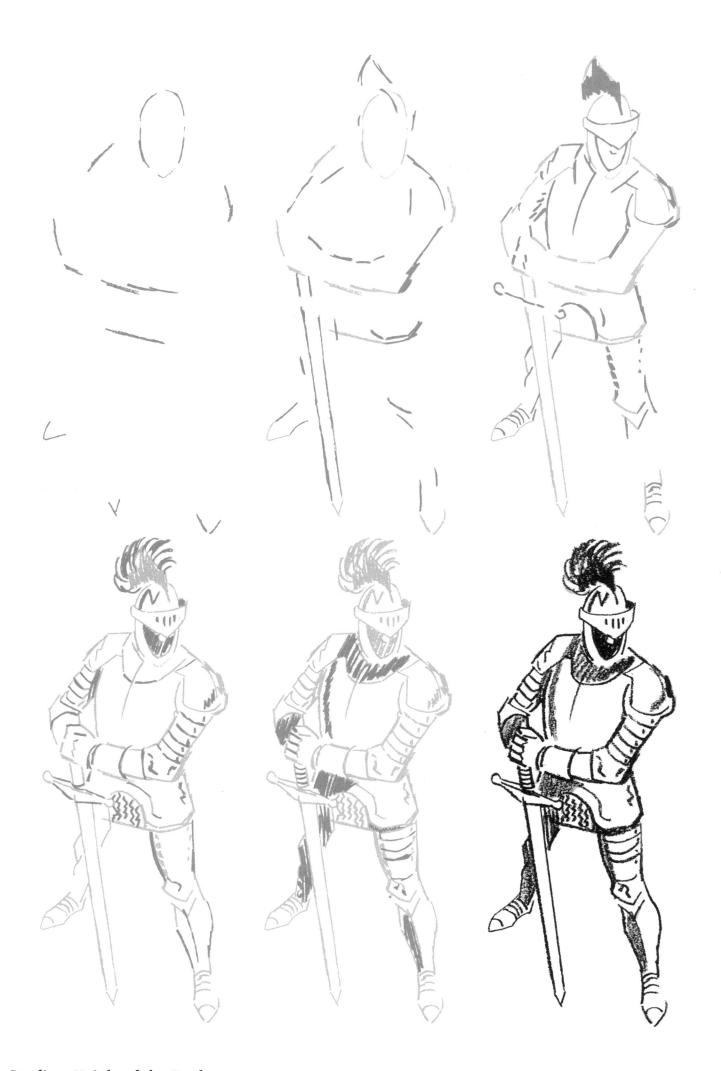

Sir Sterling, Knight of the Realm

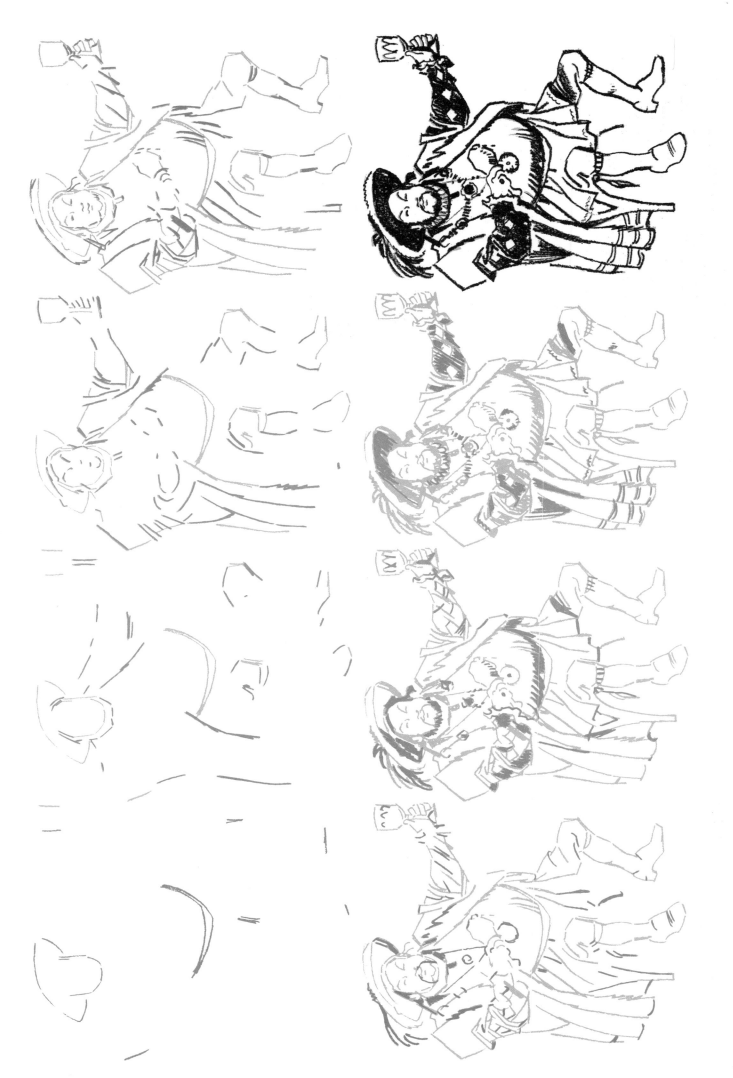

King Henry VIII

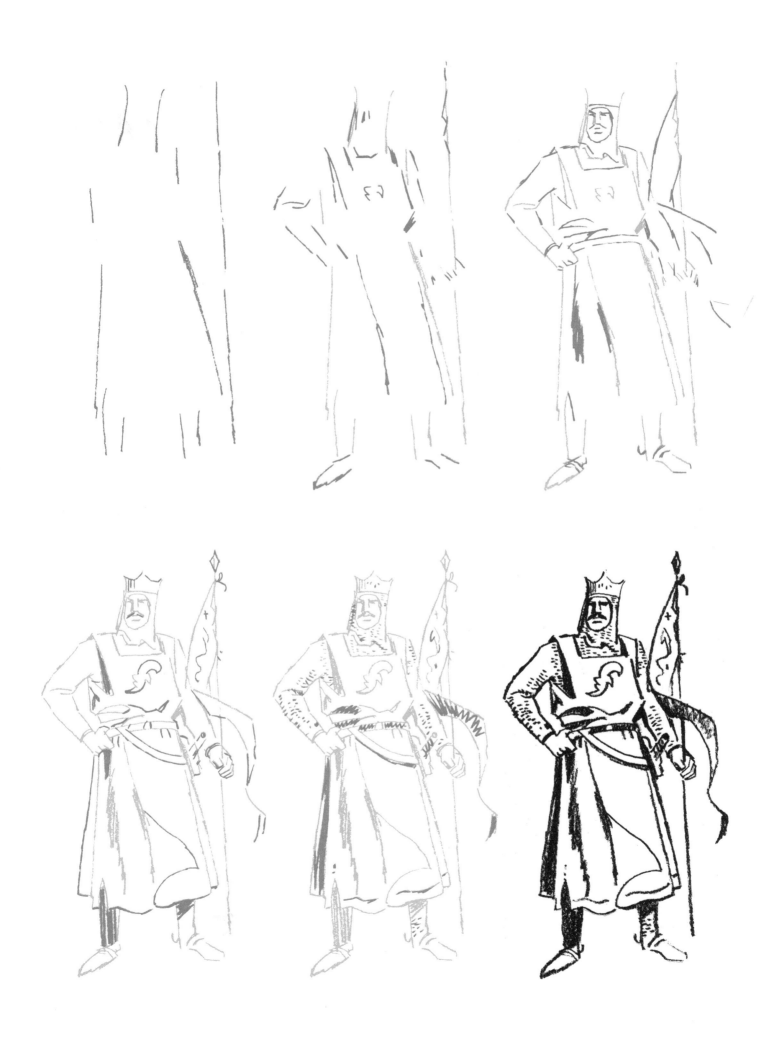

King Richard I, the Lionhearted

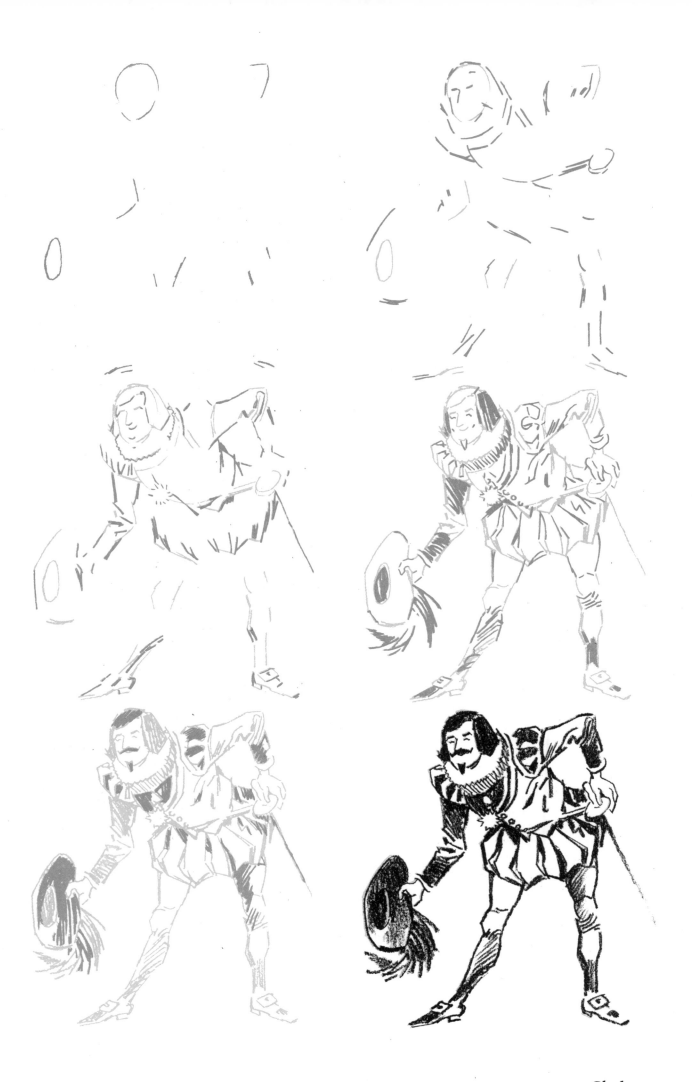

Shakespearean Actor

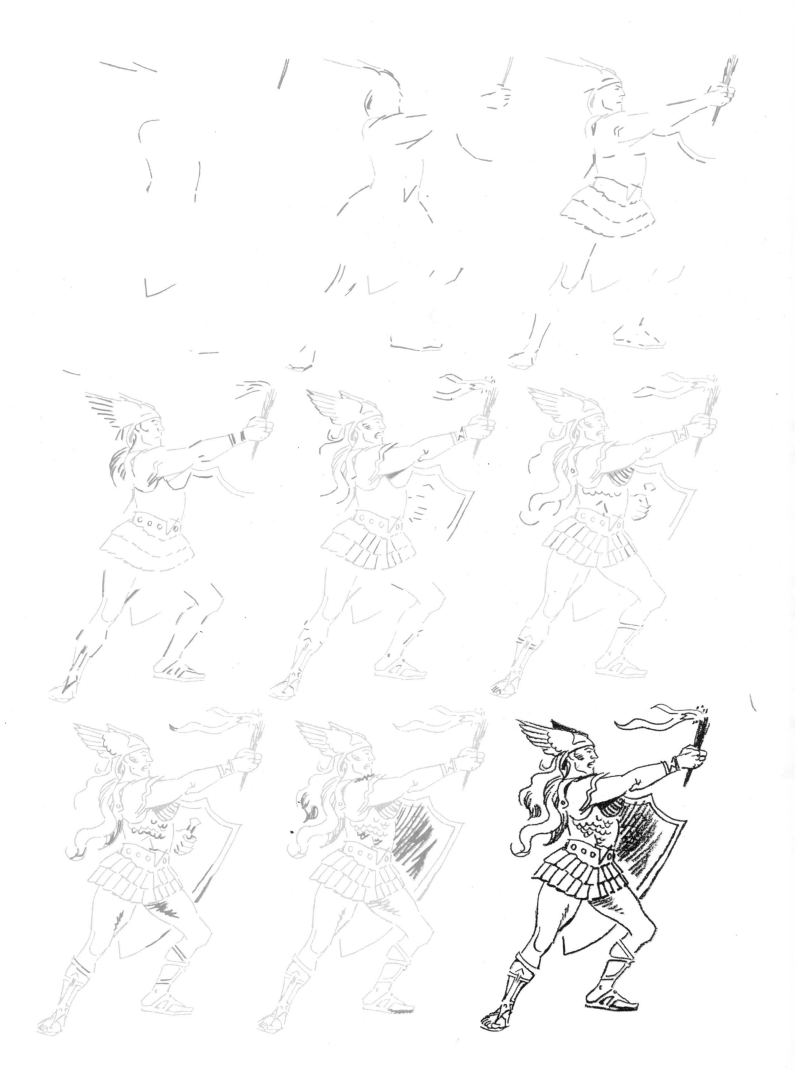

Brynhild, the Leader of the Valkyries

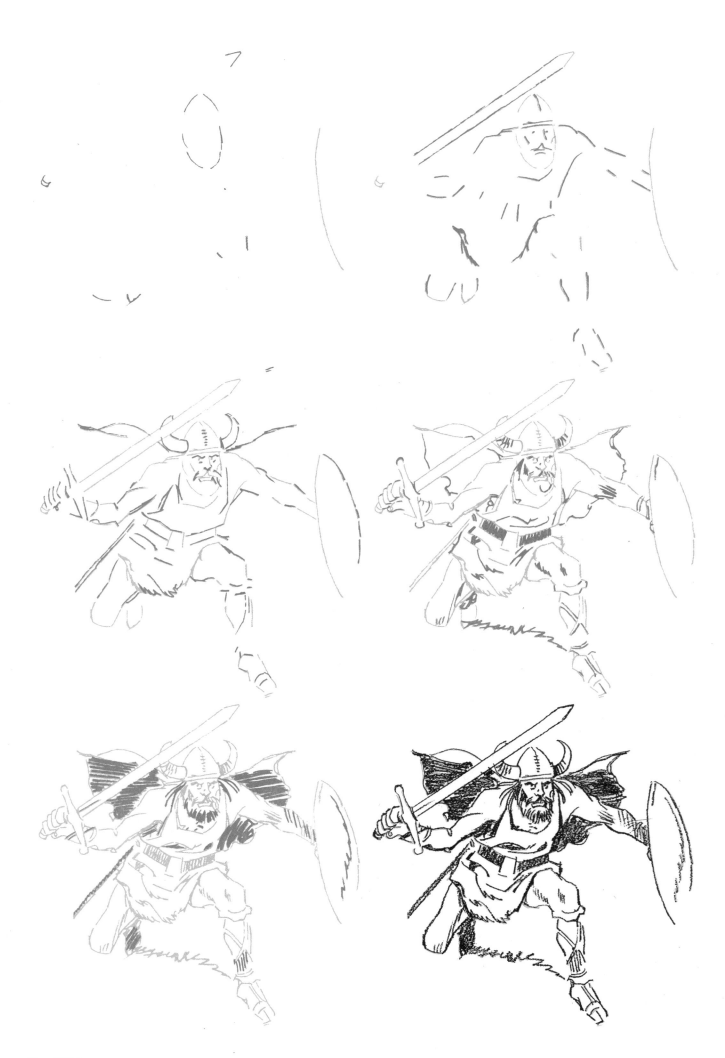

Bjorn, the Viking

Lookout on the *Santa María*

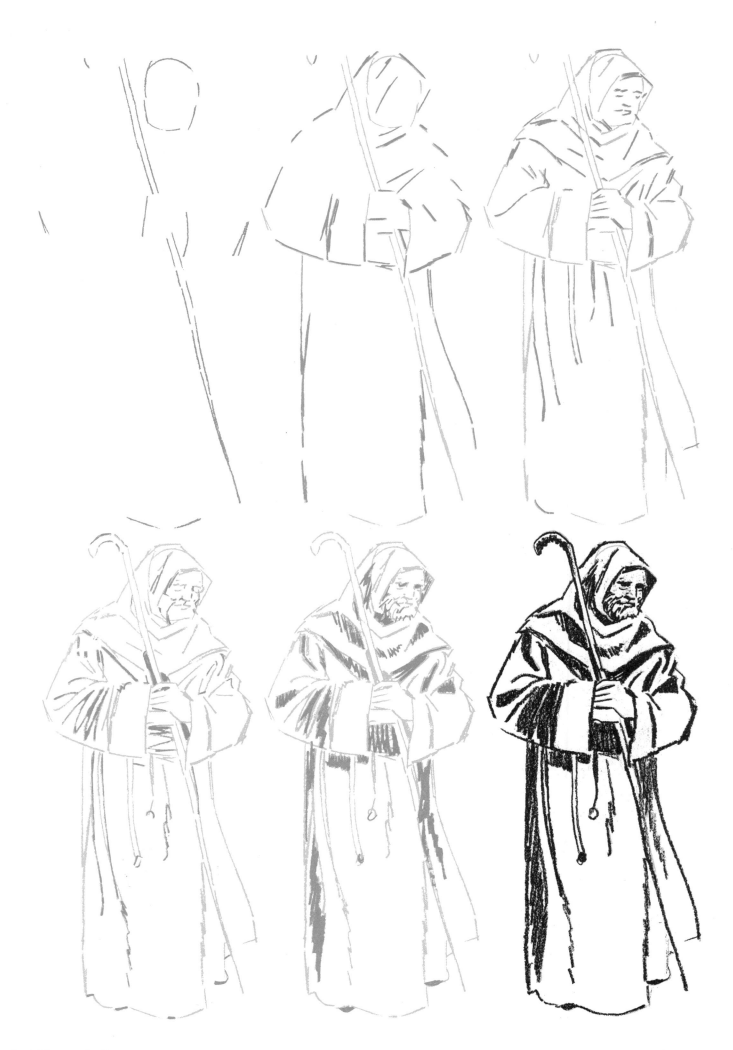

Monk, Fifteenth Century

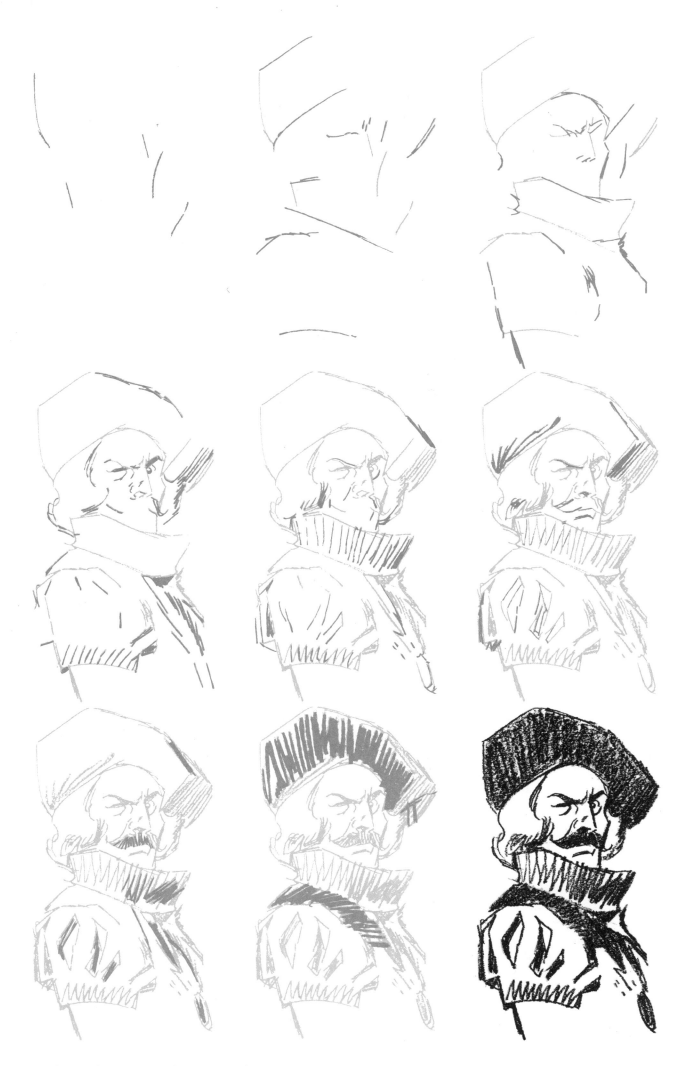

Samuel de Champlain, Founder of Quebec, circa 1608

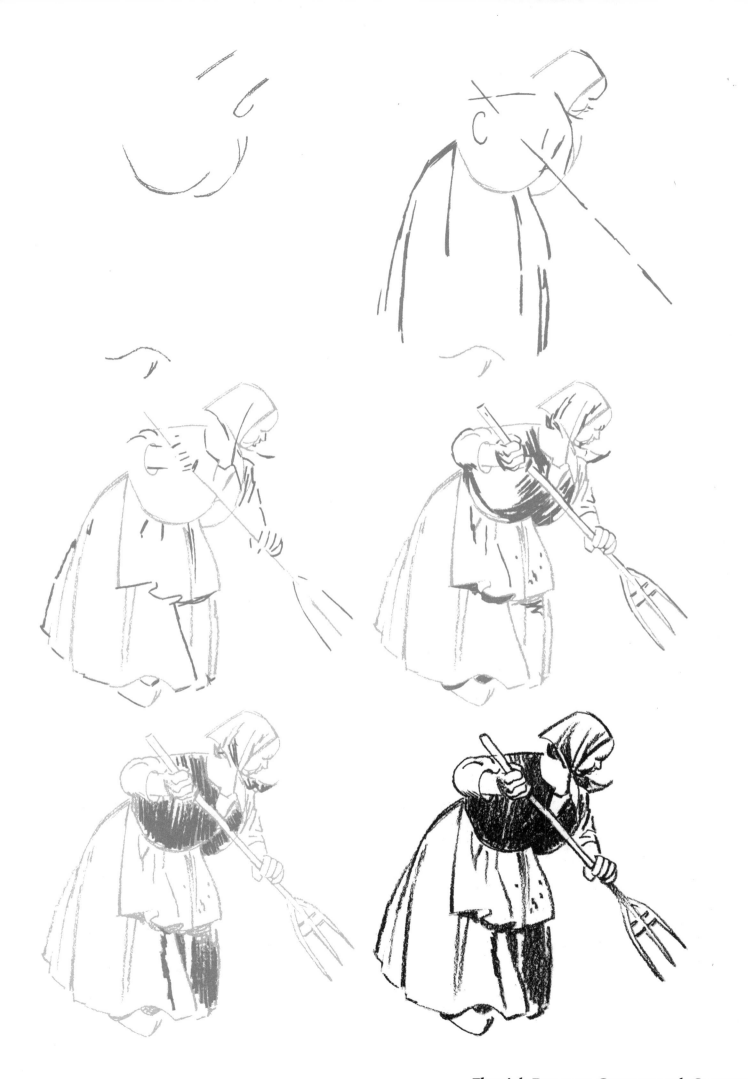

Flemish Peasant, Seventeenth Century

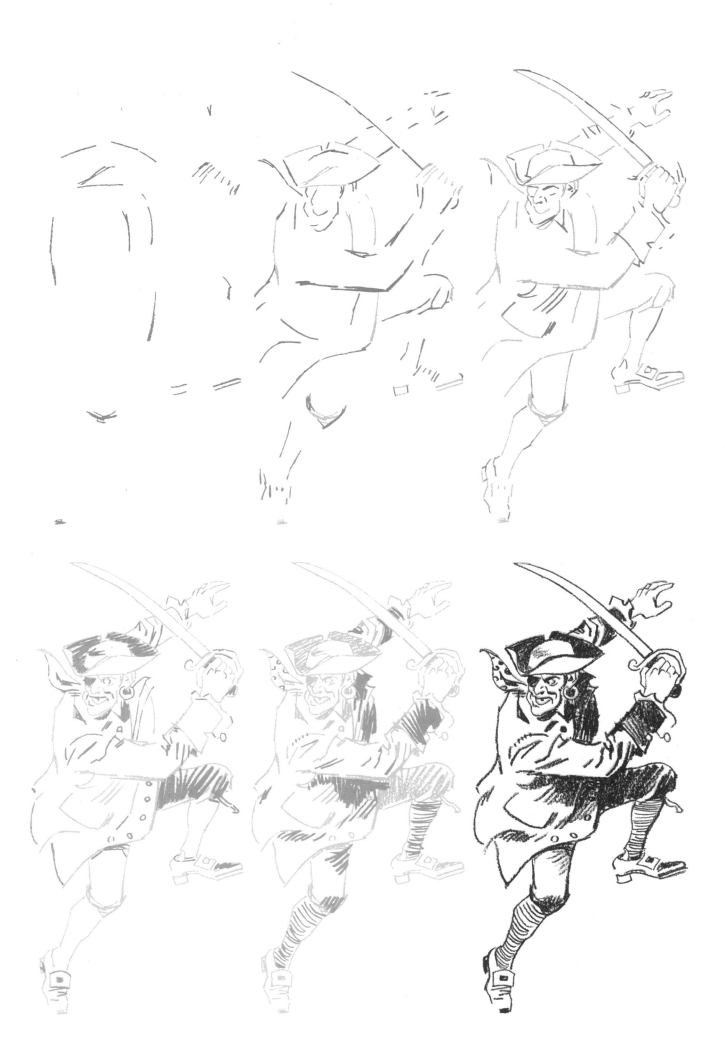

Putrid Pierre, the Pirate

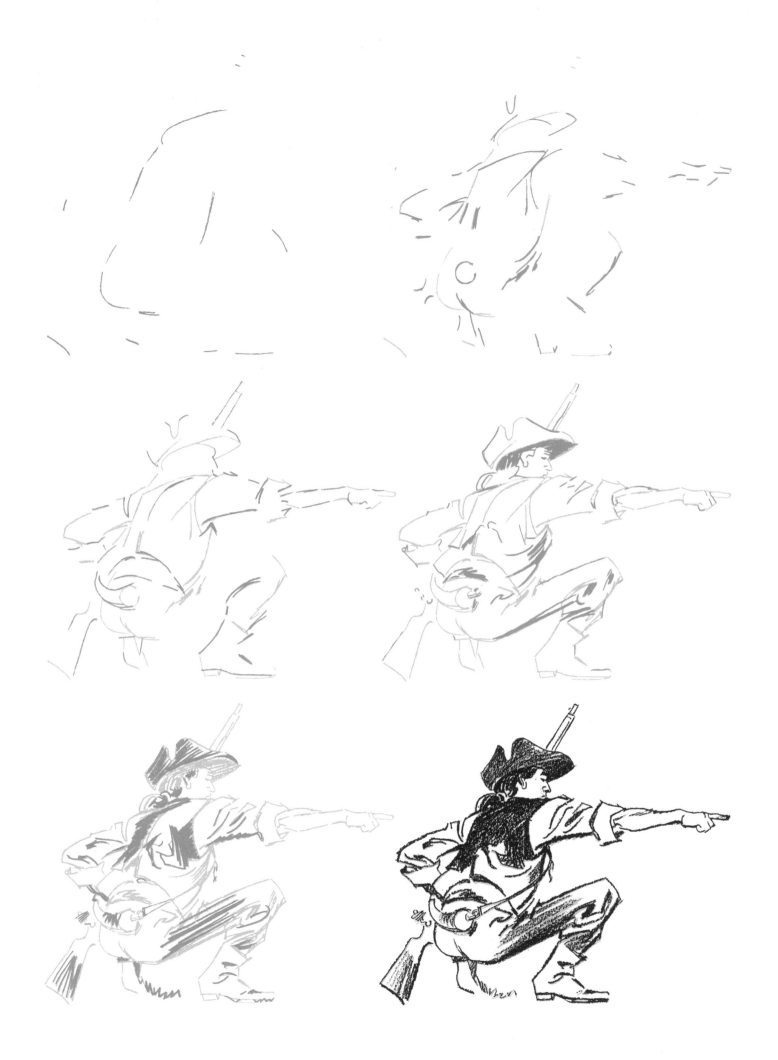

Minuteman, American Revolutionary War

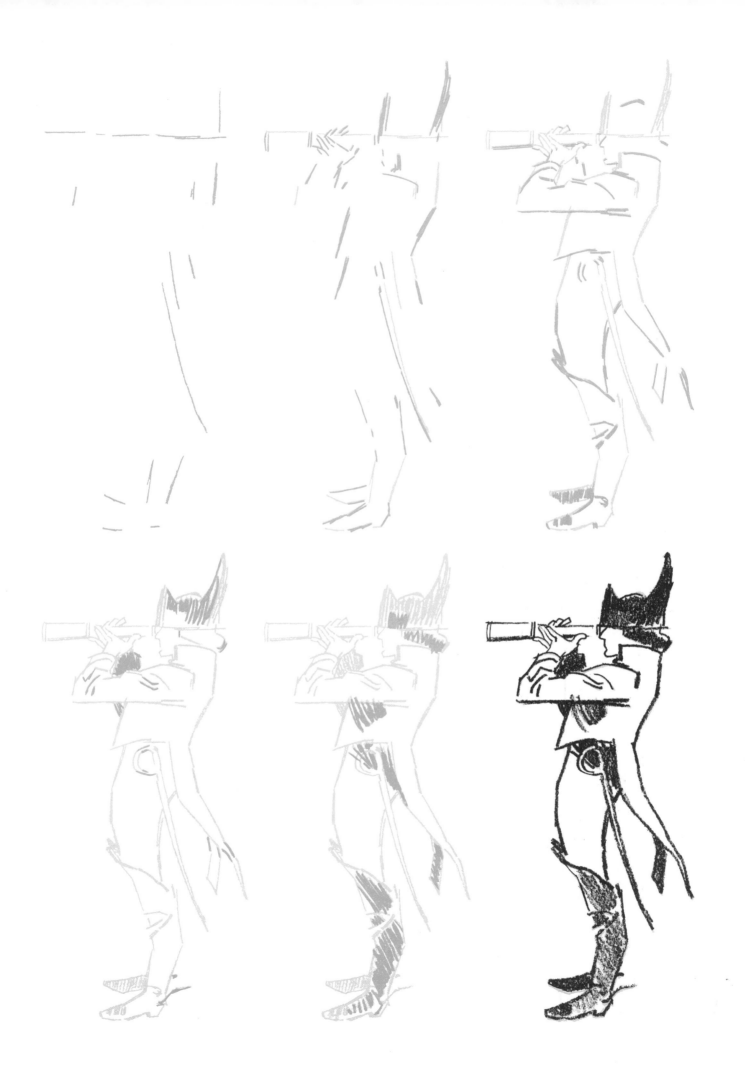

Napoleonic Officer

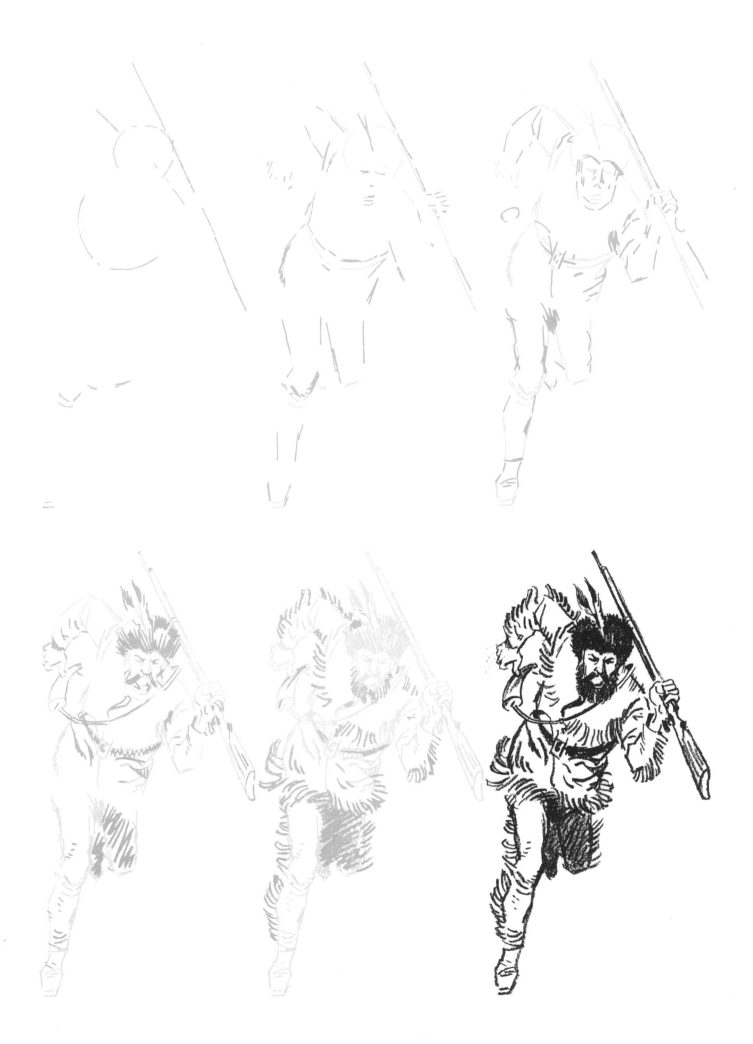

Frontiersman

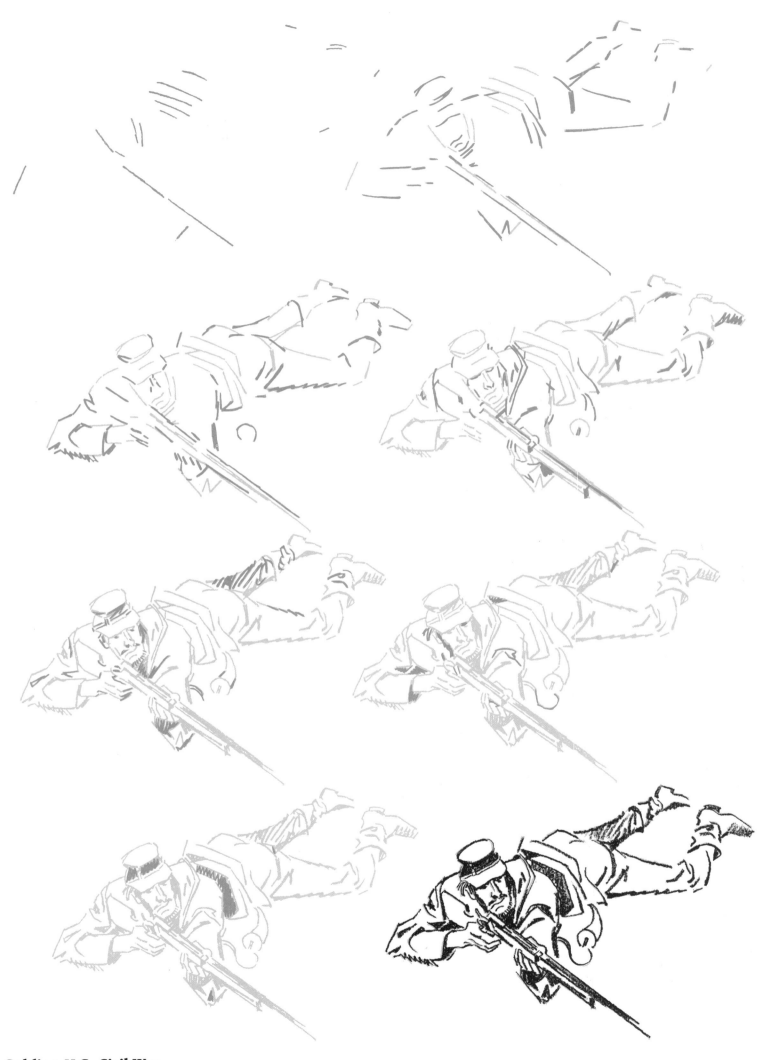

Soldier, U.S. Civil War

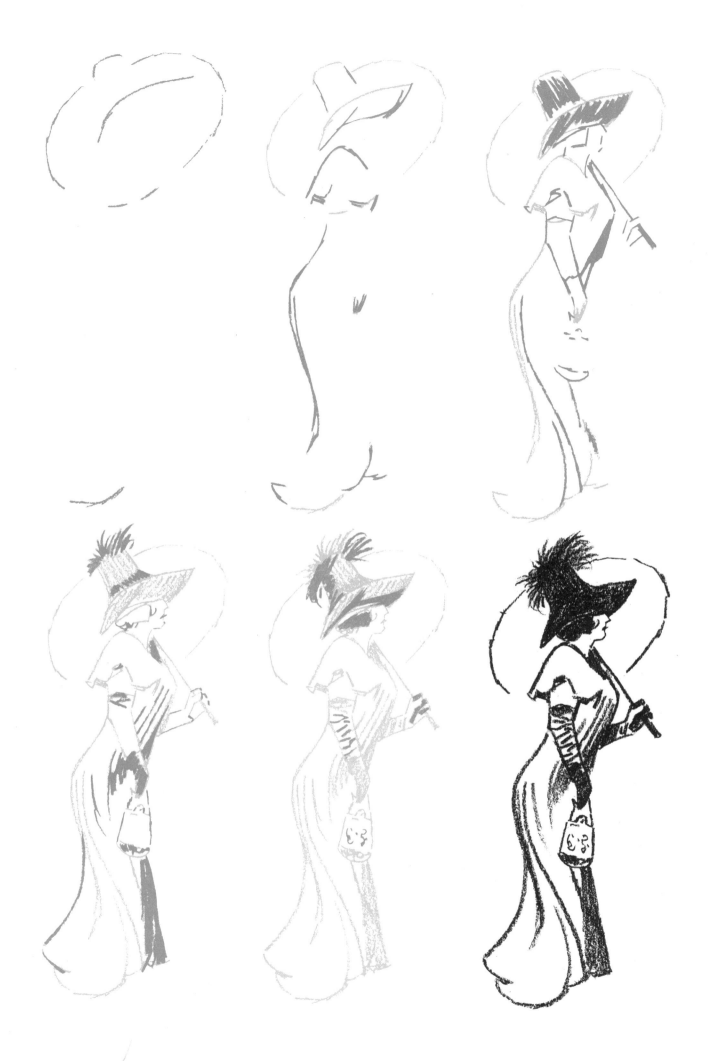

Parisienne, circa 1900

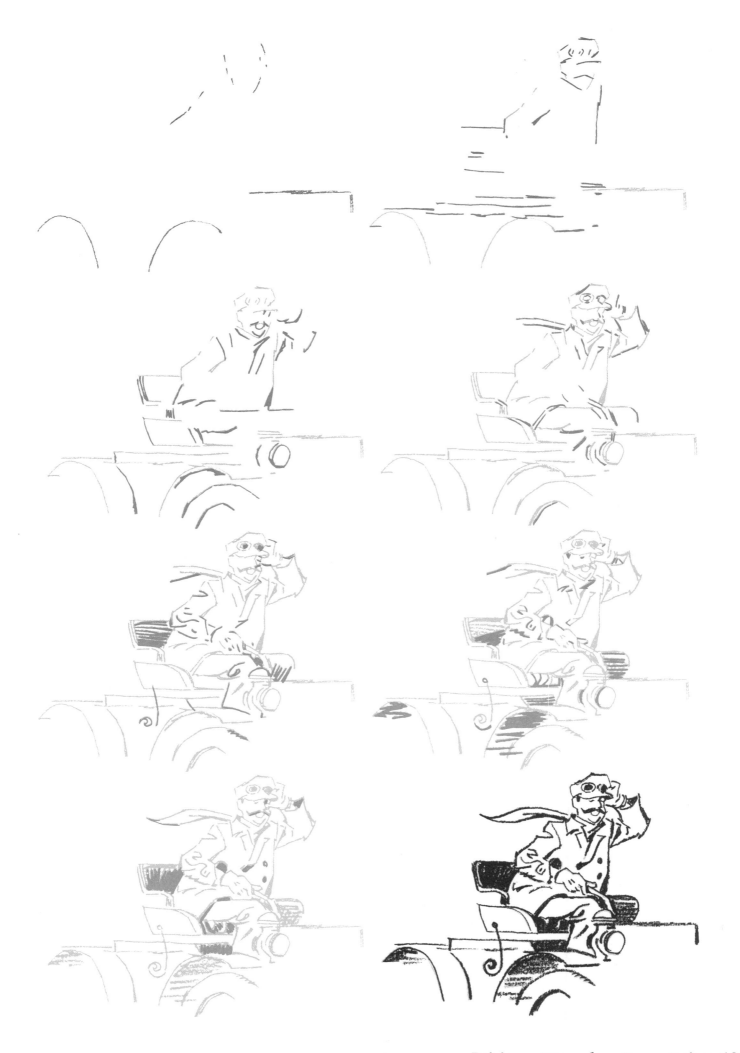

Driving a "Horseless Buggy," circa 1908

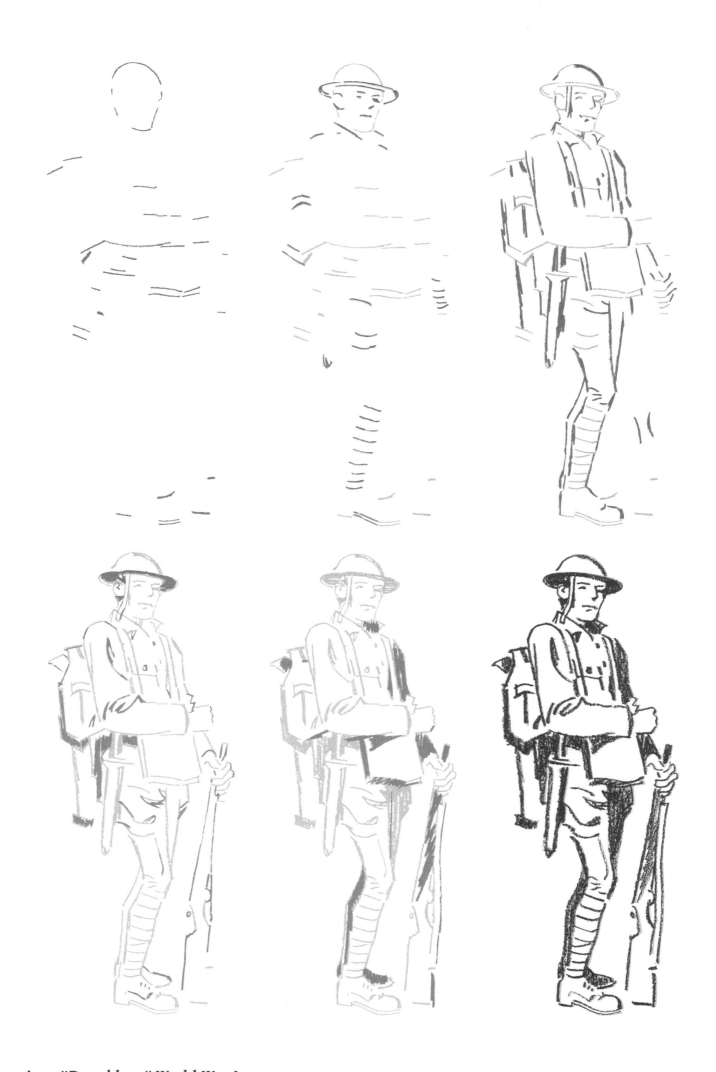

American "Doughboy," World War I

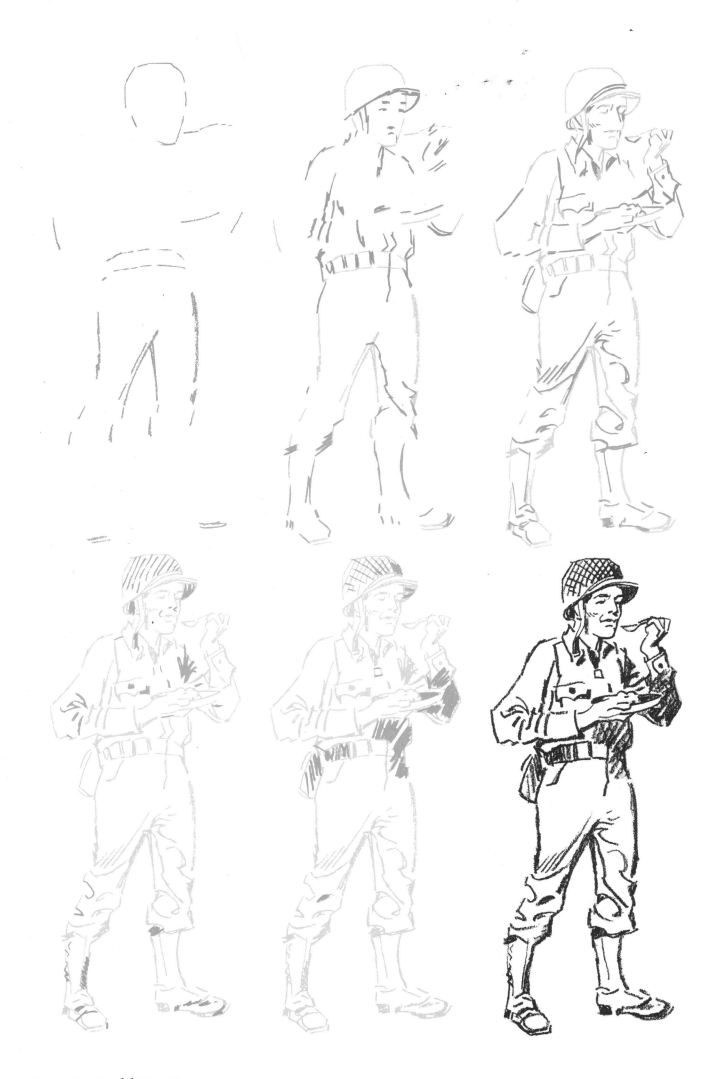

American GI, World War II

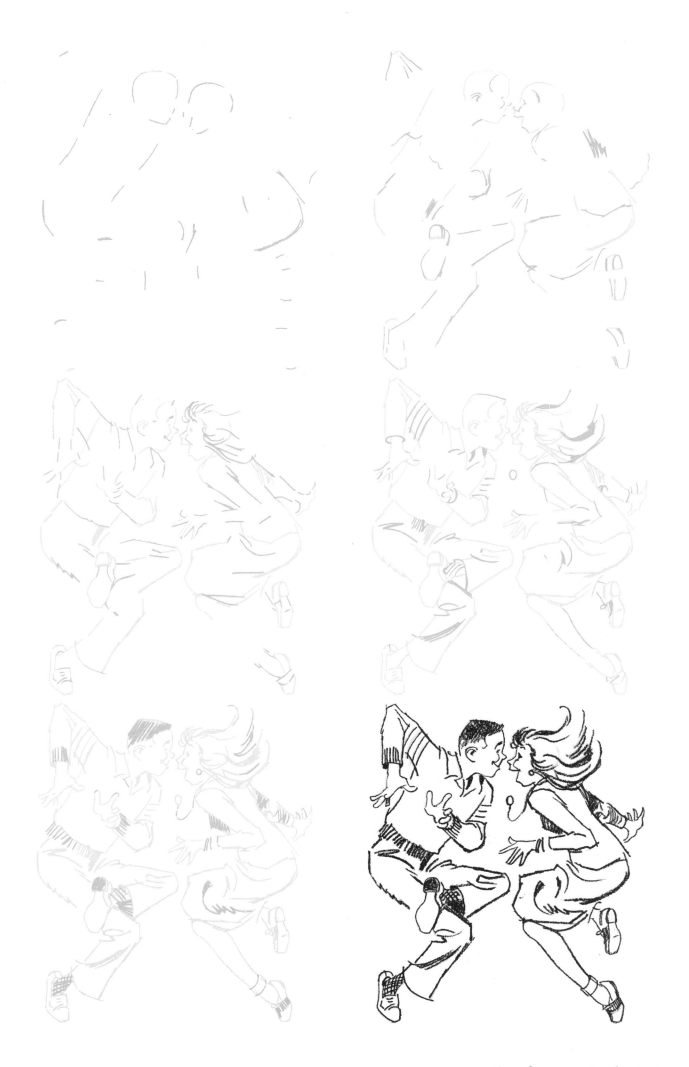

Jitterbugging in the Late 1940s

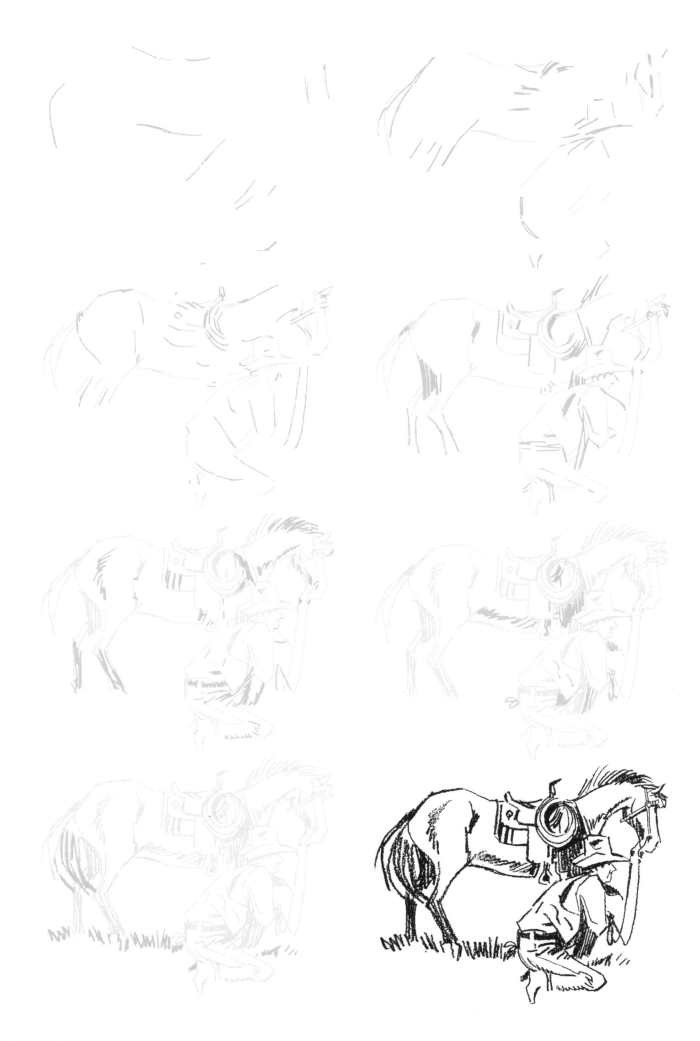

Ranch Hand

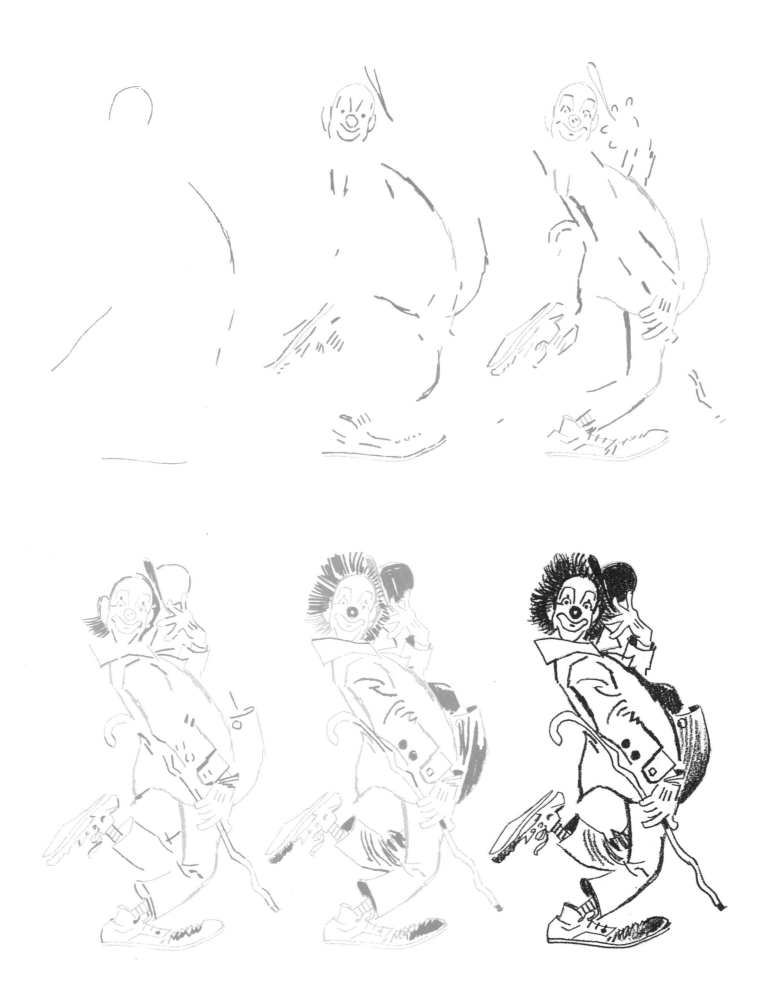

"Auguste" Clown

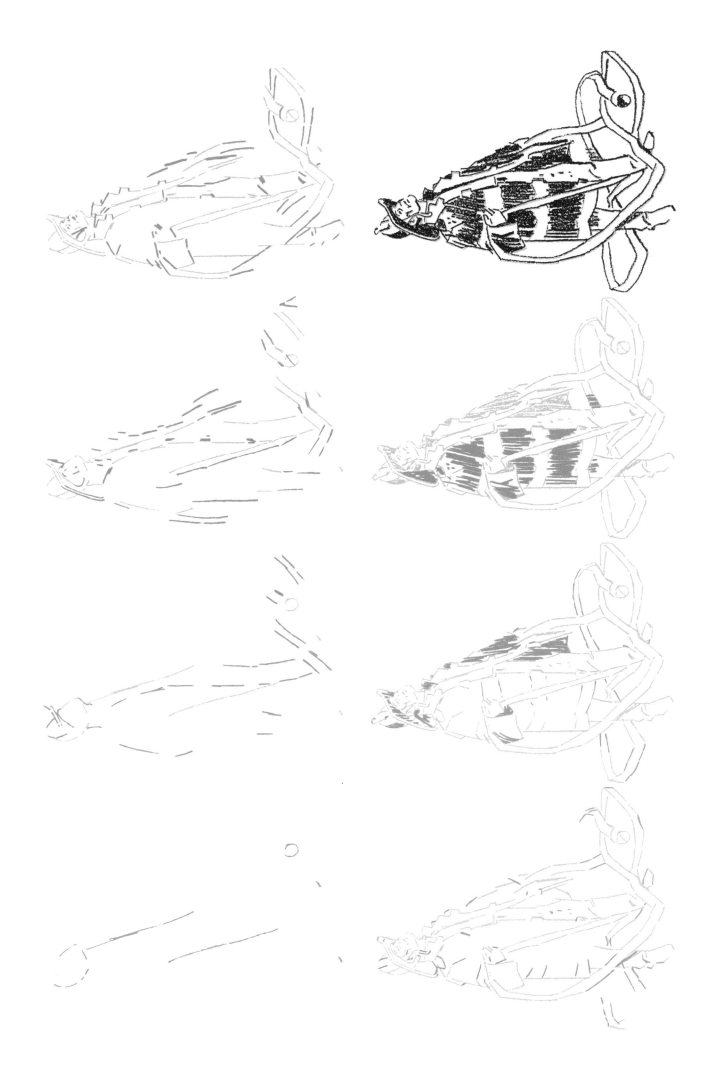

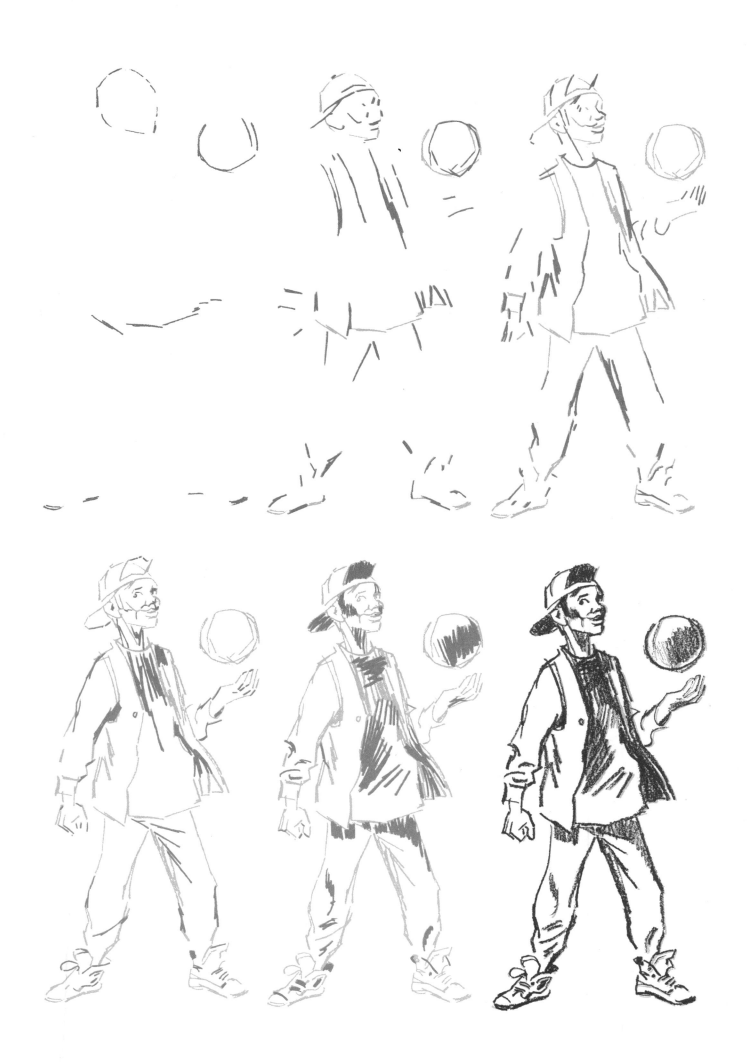

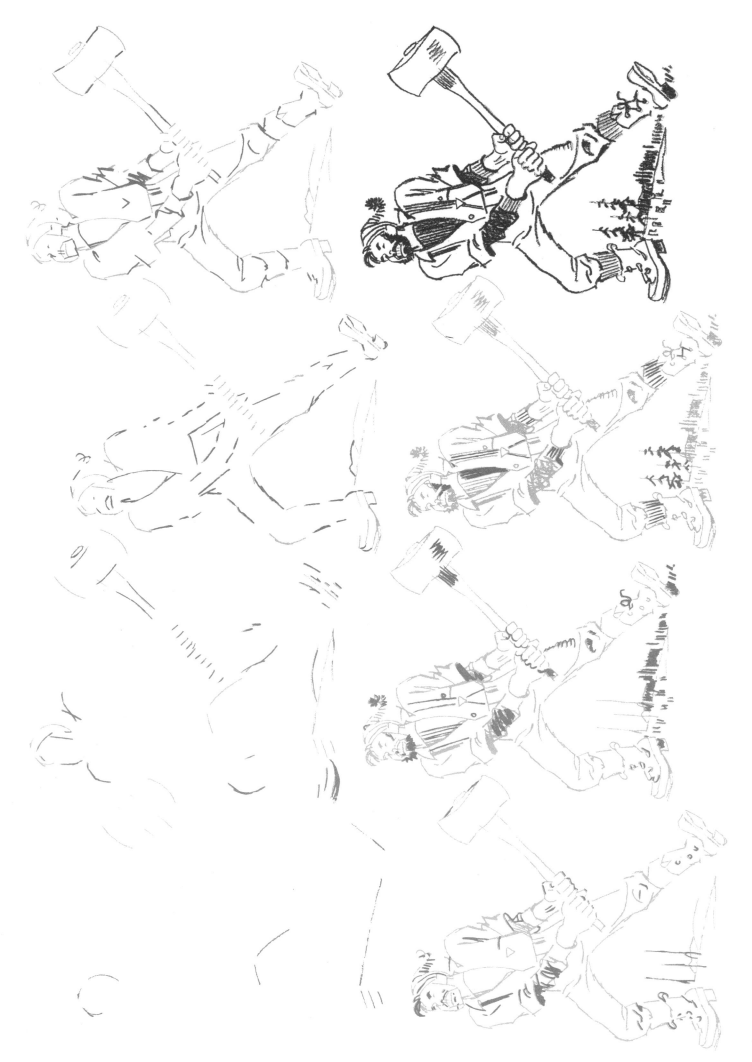

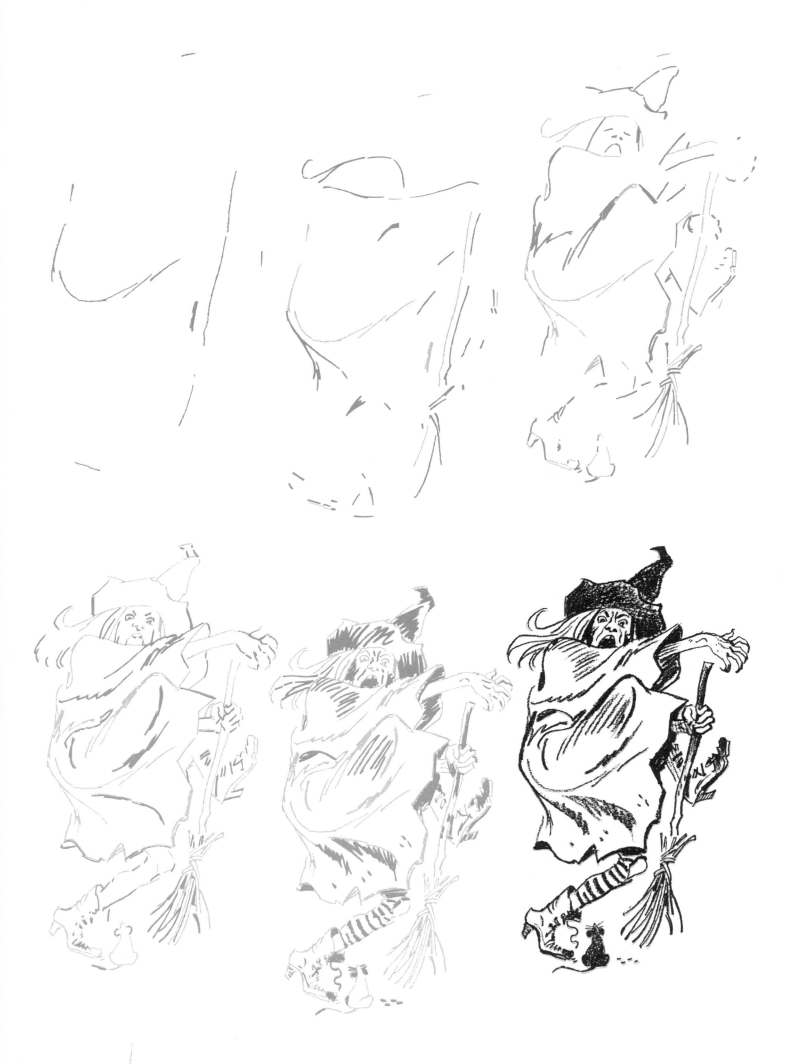

Mouse Bewitching Witch

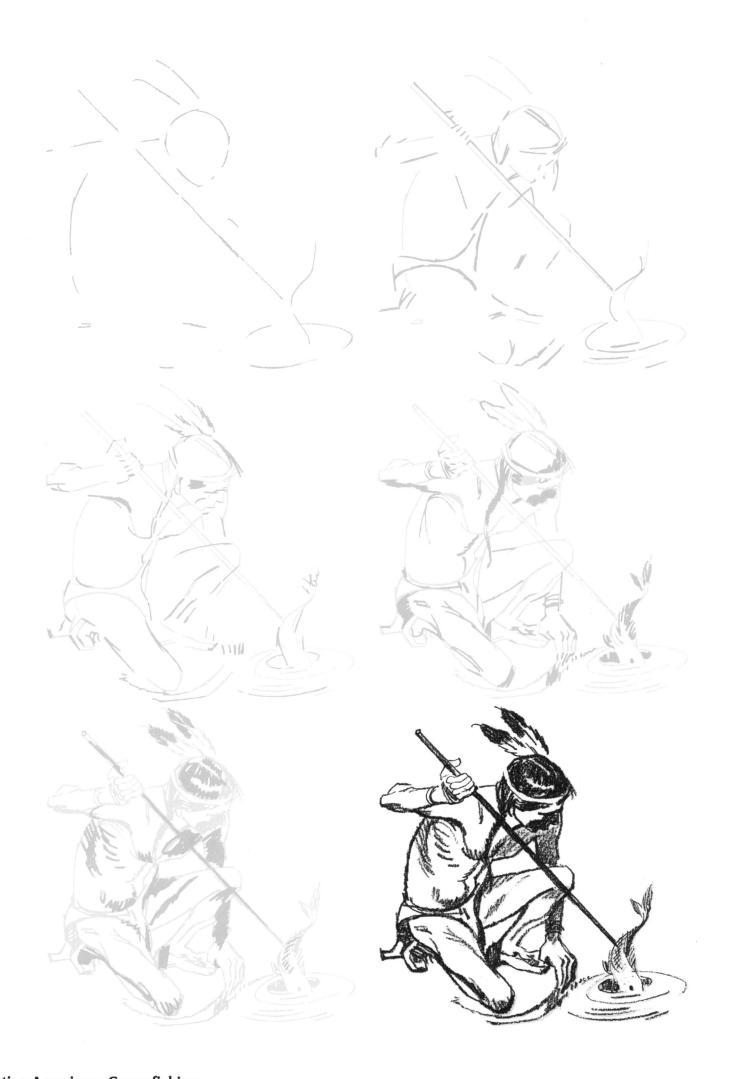

Native American, Spearfishing

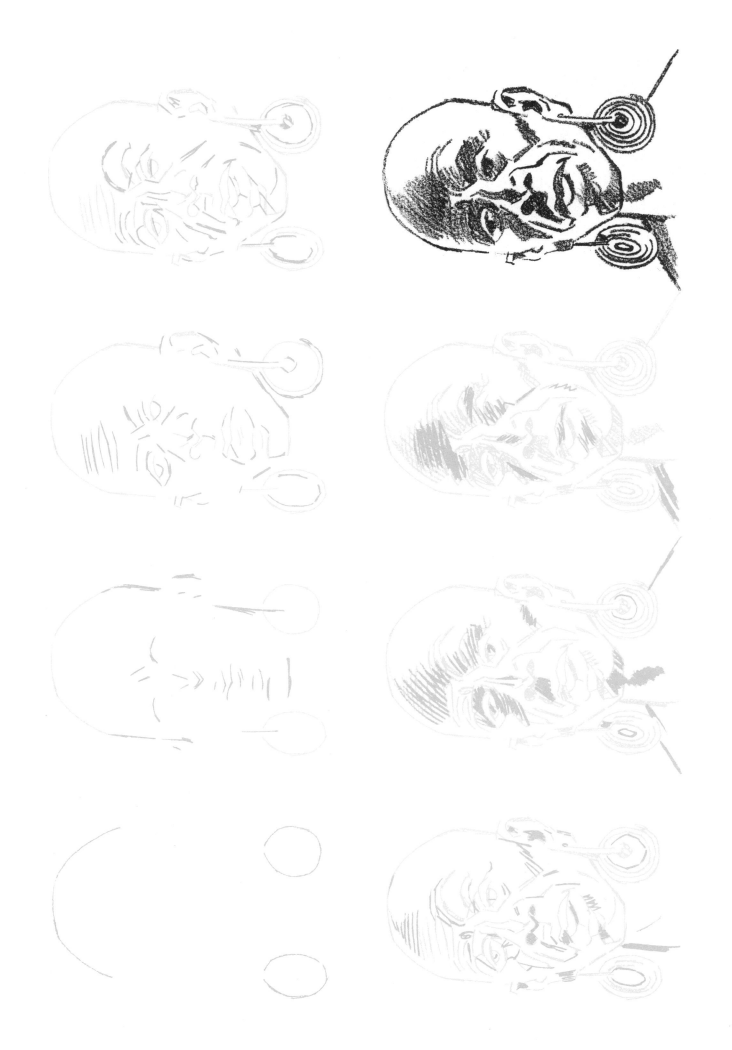

African Masai Tribesman

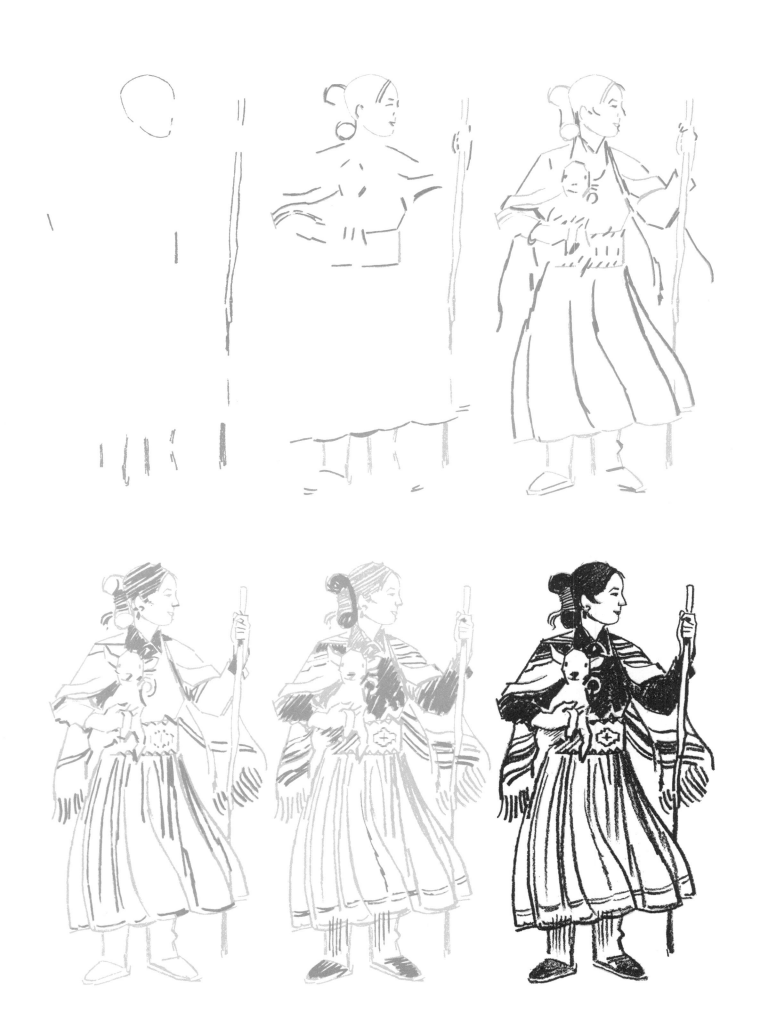

Navajo Shepherdess

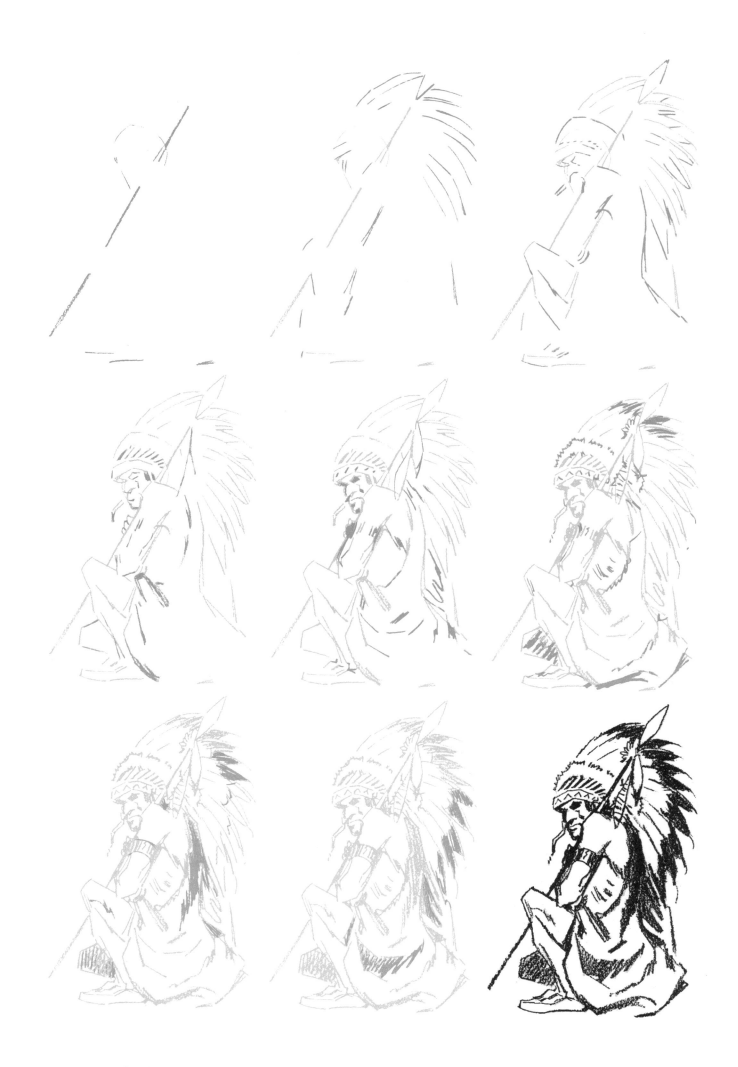

Native American Chief

Moroccan Nomad

Aztec (Pre-Columbian Mexican) at the Altar of Huitzilopochtli

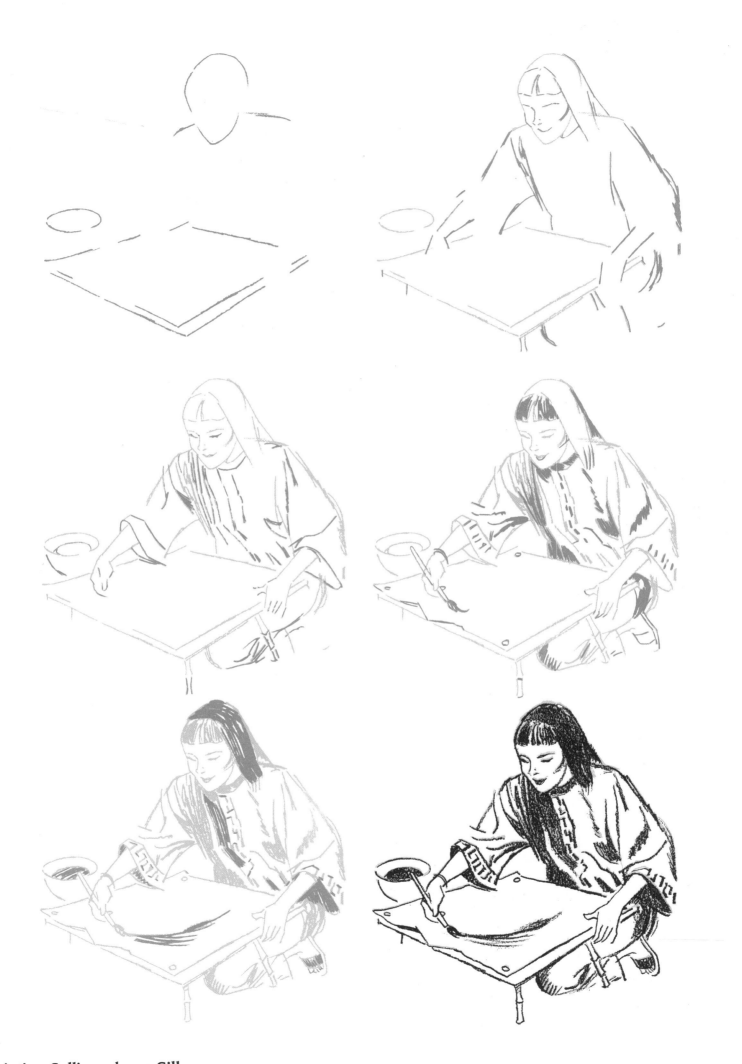

Painting Calligraphy on Silk

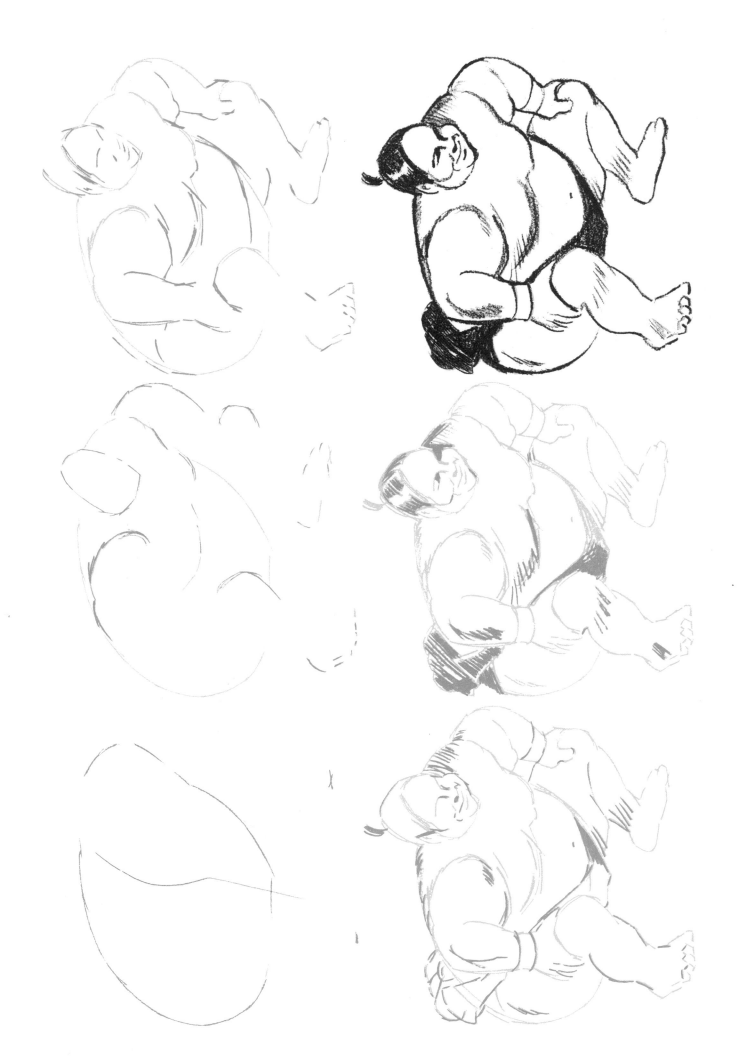

Tsuyoi Yama, Sumo Wrestler

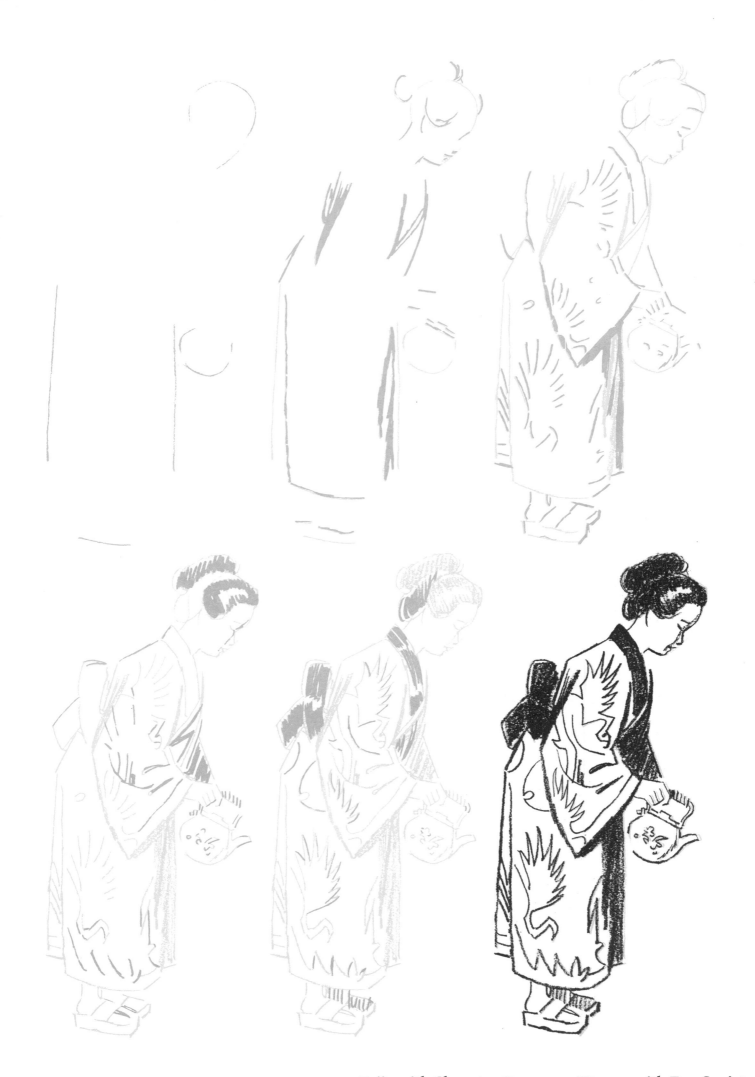

Fujin with Chazutsu (Japanese Woman with Tea Canister)

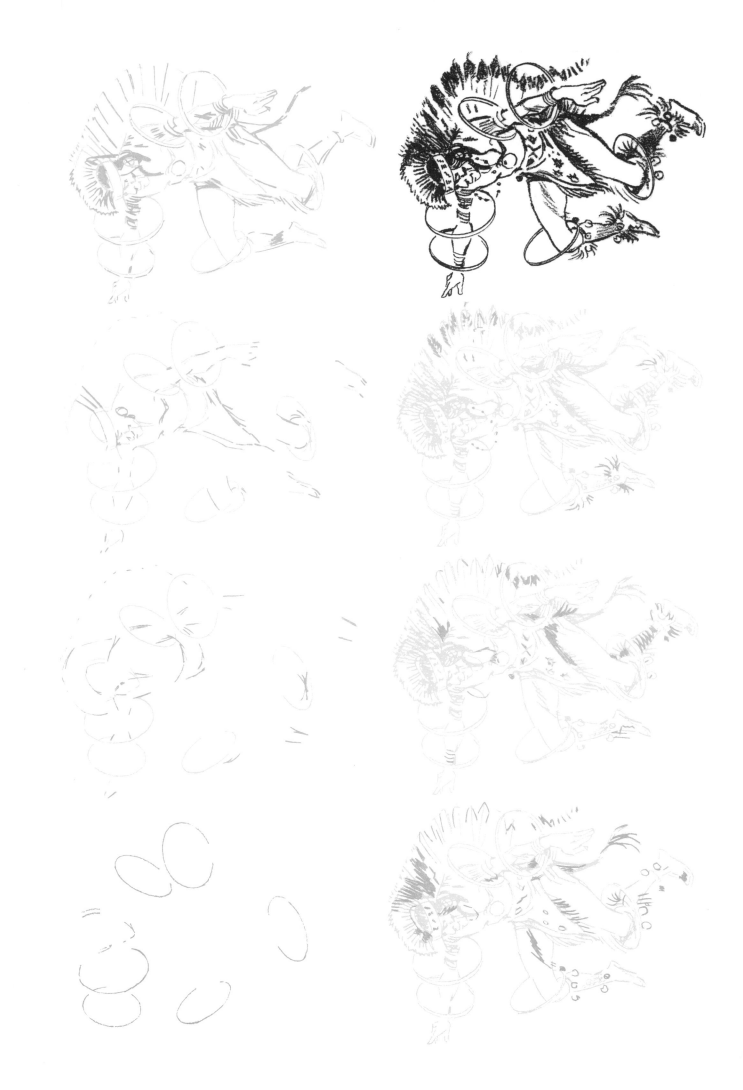

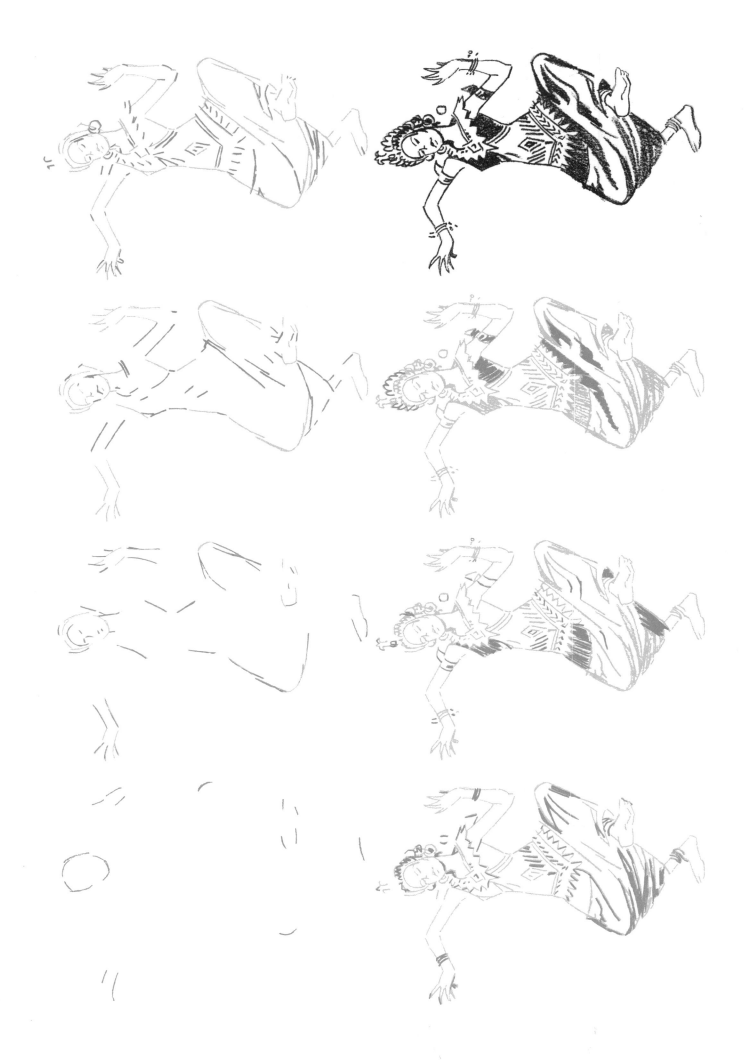

Lee J. Ames has been "drawing 50" since 1974, when the first Draw 50 title—*Draw 50 Animals*—was published. Since that time, Ames has taught millions of people to draw everything from dinosaurs and sharks to boats, buildings, and cars. There are currently twenty-two titles in the Draw 50 series, with over two million books sold.

A native of Huntington, New York, **Creig Flessel** is a graduate of the Grand Central Art School where he studied illustration with the legendary Harvey Dunn. Creig is the winner of the "Ink Pot" and the Silver T-Square awards, and has created illustrations for comic books, advertising, magazines, and text-books. Creig works in an attic-studio overlooking Long Island Sound.